CONTENTS

THE ALCHEMY OF
LIGHT AND COLOR

VI ION AND REALITY

IMAGINATIVE scientists have sometimes amused their readers by surmising how the world would appear to human beings if they had a different set of sense organs, or if their receptors were tuned to respond to frequencies to which they are now insensitive. Since, in man, the eye, the organ of vision, is the most important receiving apparatus of the body, these speculations frequently take the form of theorizing about how the world would look if our eyes were differently constructed.

That the world would appear quite different is easily shown. Bertrand Russell begins his book on the *A B C of Atoms* with these lines: "To the eye or to the touch, ordinary matter appears to be continuous; our dinner-table, or the chairs on

[9]

which we sit, seem to present an unbroken surface. We think that if there were too many holes the chairs would not be safe to sit on. However, science compels us to accept a quite different conception of what we are pleased to call 'solid' matter; it is, in fact, something like the Irishman's definition of a net, 'a number of holes tied together with pieces of string.' Only it would be necessary to imagine the strings cut away until only the knots were left." Mr. Russell, unfortunately, does not tell us why, if matter is so porous, chairs *are* safe to sit upon. I venture the statement that this is so because what we use in sitting on the chair is made of the same sort of stuff, or rather the stuff is approximately of the same order of density and texture, as the substance which is sat upon. An electron, especially if in rapid motion, would probably find the seat of a chair quite permeable. If human beings were made of stuff as heavy as that of the astonishingly dense satellite of the star Sirius they would probably experience great difficulty in keeping from falling through, not only chairs, but most everything else on earth.

Furthermore, our eyes are also made of approximately the same sort of stuff as the things we see through our eyes. But if we were equipped with eyes capable of ultra-microscopic vision, we might see through many things which now seem quite solid. With such eyes the smooth tops of tables would resolve themselves into mountains and valleys. If, like Alice in Wonderland, we could control our size by eating mushrooms, we might reduce our size to the point where we would stub our toes on atoms, or fall in love with electrons! Perhaps we could also see the sunlight in cucumbers, which, according to Swift, philosophers of a certain country were trying to extract. (It is really there, botanists now tell us.) On the other hand, if we were giants larger than the one whom Voltaire imported from Sirius we could regard the Milky Way as a small but rather hot grain of sand.

Such excursions into the two infinities of the universe, the infinitely little and the infinitely big, are quite outside the range of actual experiment. Another line of speculation is open to us, based on the probable experiences of actual organisms.

Thus it seems natural to suppose that insects see better over small areas; in any case they probably don't see very much on a macroscopic order. We, on the contrary, have a much wider purview of surrounding space, but we don't see as clearly as we would if we had lenses with the magnifying power of microscopes. Perhaps the price we pay for seeing so much is that we see so little of the little things. Moreover, as we are told by Dr. Ladd-Franklin, the eye has undergone an evolution, which means that the more recent types of visual experience which occur in us cannot occur in the lower organisms. Undoubtedly these animals, lacking some or all our color sensations, must see the world in quite unique ways.

Now if vision has evolved in the past, why should it not continue to evolve in the future? Just as there are living creatures capable of hearing what we may call super-audible sounds, so there probably are creatures capable of seeing what for us is super-visible light. If the human eye should some day be granted the ability to see in the ultra-violet region of the spectrum interesting consequences would fol-

low. All substances which emit the ultra-violet light which is now invisible would then appear to be surrounded by an aura or halo. Thus, mercury, which I have been told gives off an invisible emanation, would then be surrounded by a glowing vapor. Perhaps we would also see human bodies enveloped by some sort of penumbra, as those persons allege who claim the gift of "clairvoyance."

Such speculations may seem to possess little practical value, but they become of great theoretical interest to the philosopher. They serve to loosen up our all too ossified habits of thought. They also lend plausibility to the reality of the problem which the metaphysicians call the "problem of reality." What *is* the real world? Such speculations as we have just indulged in make it clear that the world as it *appears* to us is largely the product of our sensory equipment. That the external world *is* our set of reactions is indicated by the experiments of Stratton, who wore spectacles reversing the ordinary spatial orientation of the external world, and found that he could get along just as well after the first readjustments. Poincaré

has also suggested that the world we live in is a property of the distribution-board in the brain. This idea that our habits of thought are built around our sense experiences follows from the fact that the eye is a projection of the brain itself. The way in which this perceptual world prejudices our world of concepts is pointed out by Bergson.

If one were so minded (as I now am), one could concoct still more bizarre ideas by the following line of thought. We recognize certain types of experience as being unusual. We call such experiences "hallucinations" and "delusions." Instead of giving us the truth about reality, we suppose that they are the products of a "disordered" mind. When we incarcerate the "insane" persons in institutions we apply the test of accepted social standards. A sane or normal person is one who conforms to the standards set by the average man. The norm is established by what the majority sees and believes. But let us suppose, for reasons which Mr. H. G. Wells might give, that the insane people increase in number to the point where they outnumber the sane. It is conceivable

that in time we would not be able to control them. What would then happen? Perhaps they might put the so-called sane people into institutions, and they themselves, being now in the majority, would then run the government. The first measure they would probably enact would involve a substitution of their test for the test of sanity formerly in vogue. Now if the test of sanity *is* a social test these maniacs whom we formerly held to be victims of hallucinations and delusions would then possess veridical experiences. (The relativity of insanity must follow from any view in which insanity is regarded as a set of responses rather than as a *thing* in man, produced, perhaps, by obsession.) Something like this happens in the cases of "insane" persons who are simply geniuses in advance of their times. The way in which the abnormal may become normal is seen in the fact that unless we are subject to certain common illusions, we are really abnormal.

But hold on! someone objects,—a set of maniacs could not run the government; they are incapable of social coöperation and legislation. In reply may I point out

that perhaps we exaggerate the extent of the coöperation of sane people. I wonder whether a set of lunatics could have made a much worse job of international coöperation than we sane people—who came so near to exterminating "civilization" a decade ago? The subtlety of the problem can be indicated by the following conversation between a mathematician and a professor of abnormal psychology: The one said to the other, "You psychologists are always studying illusions—you live your whole lives in a world of false ideas." The reply of the psychologist was this, "Did it ever occur to you that what you call truth is only a delusion so deeply rooted that you haven't been able to bring it up to the light?"

At this point in the argument someone is likely to demur, and point out that the test of reality is not solely a social test, but others are also applied. True, it will be granted, when a man sees pink elephants or snakes in his bed of the existence of which he is sceptical, he appeals to his friends, and if they see them also his faith in the validity of his own perceptions is remarkably strengthened. But collective

hallucinations may sometimes occur. Group hypnosis can be produced. (Descartes considered the idea that a malicious demon might be misleading the whole human race into believing that there was an external world.) Certain religious skeptics have even supposed that the alleged miracles of the New Testament, such as the Resurrection, were due to group hallucination, produced by suggestion and self-hypnosis. Since this is possible we must bring in the other tests. If we see something, the existence of which we doubt, we also try to feel it. Thus one sense is used to supplement and check up the other. But in reply may I point out that this does not give us absolute certainty. Why should we put more faith in touch than in vision? We sometimes see things which we cannot touch. The mirror image of a pin is a case in point. To explain away the image by appealing to the principles of geometrical optics does not finally dispose of the matter. There are too many tactual illusions, and too many unfelt realities to rest the whole case on touch. It has been pointed out that sight is simply "anticipative touch,"

and that both give us only relative truth.

The upshot of this whole matter is that we must conclude that what the world is, aside from the way in which we perceive it (or the way in which it *appears* to us) we do not know. Only a god (or a philosopher) can tell us what ultimate reality is. We have heard much these last few years concerning the psychology of philosophy—what we now need is a philosophy of psychology!

Instead of attempting the heroic task of pursuing the Absolute on a grand scale, let us restrict ourselves to the problem hinted at in discussing the evolution of vision. We saw that what we perceive is a function of our sensory equipment. Now how did the senses come to be what they are? By passive adaptation to an eternally fixed environment of external nature? But isn't it also true that the environment was created by those sense organs as they came into existence? Doesn't the eye create the light it sees as truly as the light builds up the retina which responds to it? If so, which preceded which? (Frequently the glib use of the terms "organism" and "environment" sloughs over

certain very baffling problems.) Rather than try to answer such profound questions in general terms, let us turn to a specialized phase of the problem, the problem of color vision. Here is an excellent opportunity to come to close grips with this problem of the relation of the subjective and the objective.

THE STATUS OF QUALITIES IN MODERN THOUGHT

THE statement made recently by a psychologist that "psychology is in chaos" is certainly true when it is applied to the theoretical foundations of the subject. There are many schools and systems of psychology. One of the most chewed upon bones of contention among the various schools is the problem of *qualities*. The discussion has been further aggravated by the avowed intention of the behaviorists to ignore, or to reduce to terms of physical science, all those conscious experiences which have hitherto been admitted to be the content of the mind. And in philosophy the riddle of qualities is no closer to solution than it was centuries ago.

Indeed, if we personify quality we might call it the Wandering Jew of philosophy—homeless and with no place to put its head. The physicist, concentrating on the more permanent or more measurable aspects of the external world, has eliminated colors, odors, sounds, tastes, and temperatures from his world of ultimate elements. Molecules, atoms and charges of electricity (electrons and protons) do not have the *secondary qualities* of colors, tastes, etc., but only the *primary qualities* of shape, mass and inertia. The physicist's world is an abstract universe of measurable quantities, stripped of all the richness and beauty which we ordinarily impute to nature. Therefore, in what some would now call traditional psychology, room was made for the sensed qualities, which the physicist expelled from his world, in the concept of *sensations,* conceived as elements of conscious states. This took mind, with its secondary qualities, out of the world of physical nature. Now, as we have seen, behavioristic psychology, wishing to "naturalize" man, has had to reject the notion of mind as constituted of elements with qualitative at-

tributes, and substitute sensori-motor dis-
criminations of various wave-lengths of
light for the various colors, and analogous
explanations for other experiences.

We speak of objects as being red or
green, cold or hot, sweet or sour, and so
on. Where are these qualities which, to
appear, seem to require both an organism
and an environment? Is the red of the
rose an attribute of the rose? The an-
swer to this is not as obvious as it may
seem. The unsophisticated person (the
"naïve realist") believes that the red is
really in the rose. But the physicist as-
serts that the color depends on the light
reflected from the rose, and that it is this
reflected light which we call red. This
would seem to indicate that the rose is (or
has) every color *except* red. But the
physiologist knows that the rose which ap-
pears red when looked at directly may ap-
pear yellow or gray when the image falls
upon the peripheral part of the retina.
He is therefore inclined to regard color as
an attribute of the eye. Finally, to the psy-
chologist who believes in consciousness, the
red is neither an attribute of the rose, nor

the light, nor the eye, but a definite qualitative element in consciousness.[1]

It is because of such facts as color blindness in particular, and, in general, the variability of the world of experience, in contrast with the assumed invariability of the objective physical world, that the psychologists in the main accept the notion that colors (and all secondary qualities) are subjective, or in the mind of the perceiver. On the other hand, this tendency to deprive the world of nature of its tingling warmth and color, to make the beauty of the sunset like the hallucinations of an insane person (the analogy is quite exact) is very depressing to the artistic soul. Here is another case of that conflict of the scientific and poetic spirits which Mr. I. A. Richards has discussed. Science says that the tendency to humanize the external world (empathy or *einfühlung* is the technical term applied to this) is a relic of the anthropomorphism of primitive man. But poetry, in the words of Walter Pater, says that "Color is a spirit upon things by which they become expressive to

[1] Adapted from J. H. Parsons' *Introduction to the Study of Color Vision*, 1915, p. 22.

the spirit." A somewhat similar view was argued for by Goethe in his "Treatise on Color" (*Farbenlehre*), where he declares that *the eye forms itself in order that the light from within may meet the light from without*. And in the words of Bosanquet, "If the world apart from knowledge has no secondary qualities, it is hardly anything of what we care for."

Now if the materialistic psychologists insist upon pushing qualities out of the experiencing organisms, and if the physicist will not tolerate them in his ghostly world of masses in motion, where in the world are qualities? Are they, like the fictitious creatures of mythology, only imaginary entities—kept alive, perhaps, by philosophers to have something to dispute about?

THE HISTORY OF THE PROBLEM OF QUALITIES

THE world is presented to sense awareness in the form of qualitatively different kinds of experience. But in the midst of these qualitative changes there are foci of permanence. To explain this fact of permanent realities enduring through

change it has been the natural tendency to postulate some underlying substratum as the seat of qualitative changes. One of the earliest problems of Greek philosophy was to describe the nature of this original essence or stuff. From the time of Democritus, who first assigned to secondary qualities a subjective status, primary qualities have been taken to refer to those properties of objects (or "matter") which enable the physicists to measure, in the $c. g. s.$ system, the more invariable aspects of nature. In the early period of modern thought this doctrine of the subjectivity of secondary qualities was revived by Galileo, and is embodied in the views of Newton, Descartes and Hobbes. The effect of Locke's view was to strengthen the distinction. Berkeley alone, in his time, held that secondary qualities are in the same boat with the primary qualities.

Modern psychologists refused to follow Berkeley. Physicists also reaffirmed the dualism between primary and secondary qualities. The notion of sensations as elements of consciousness, having certain attributes such as *quality, intensity,* and *duration,* and as bearing a certain relation

·[24]

to the intensity of the stimulus, was formulated by E. H. Weber, and extended by Fechner, whose well-known law of psychophysics states that the sensation varies as the logarithm of the stimulus.

The notion that the qualities of sensation are the subjective correlates of the magnitudes of the primary physical system was incorporated into Johannes Müller's doctrine of the "specific energies of the nervous system." This doctrine states that the quality which characterizes any mode of sensation is not dependent upon the method of stimulation. For example, mechanical stimulation of a sense organ (as the eye) may yield the same (visual) sensation as will chemical or electrical stimulation of the same receptor.

The foregoing condensed history of this problem of qualities brings out the fact that most of the problems of modern psychology grow out of this dualism of mind and matter which the distinction between secondary and primary qualities fostered. It should be particularly noted that *by definition* the qualities are not identified with the external conditions. This is evi-

dent from Newton's statement, "The rays, to speak properly, are not colored."

It is also evident that if Galileo, Newton, and others, had stated their philosophies of science in different terms, the subsequent formulation of psychological problems would have been different. To solve these problems does it not follow that while we must take into account the very real qualitative characteristics which traditional psychology put into the mind, we must also overcome the dualism which is so unacceptable to our monistic inclinations? Granted that such a solution is desirable, is it also feasible? And how may it be accomplished? It seems to me that it can only be achieved by widening our conception of physical reality. To overcome the dualism of matter and mind we must retrace the history of physics and get the secondary qualities back into the objective world. (This is not a radical idea to those who are familiar with the views of Dr. A. N. Whitehead.) Before suggesting my own hypothesis it will be well to dispose of the behavioristic "solution."

IRON NERVES

SINCE the behaviorist considers the human organism to be nothing but a physico-chemical machine, he must deny the existence of anything different from observable physical processes. Very well. Let us take the experiment which Professor R. S. Lillie has devised as an analogy for exhibiting what goes on in nerve conduction. Let an iron wire be wrapped around a glass rod and the whole thing be immersed in a strong solution of nitric acid, and then transferred to a jar containing a weak solution of the acid. When the wire is touched by a base metal a wave of effervescence can be observed to travel rapidly along the wire from end to end. After being excited, a brief period of inactivity must follow before "restimulation" is possible. This corresponds to the "refractory" period of the nerve. Other effects, such as summation and chronaxy, can be duplicated. Let us further assume that the exposed end of the "iron nerve" corresponds to the exposed nerve of a tooth. The behaviorist must then either (a) admit that the iron nerve, like the ex-

posed nerve of the tooth, actually suffers pain—in which case he is an anthropomorphist, and no longer a good behaviorist; or (b) he must deny that human beings suffer pain in such situations—in which case he is denying fact, and is therefore no longer a good psychologist; or (c) he must admit that this analogy breaks down as an adequate picture. This is equivalent to saying that something goes on in neural processes in an individual which is not observed to go on in an iron nerve. So far as the behaviorist is concerned, the mere addition of laryngeal muscles to shout "ouch!" when the dentist touches the nerve, and the increase in quantitative complexity of nerve tissue to form a brain, can add nothing to the picture of the iron nerve. This argument can be applied to *any* theory of nerve conduction, so long as phenomena involving *only* primary qualities are admitted. This shows the inadequacy of any psychology which expels secondary qualities from the conscious organism, and then refuses to clothe physical reality with the cast off garments of qualitative content.

Now, personally, I am willing to admit

that the iron nerve has flashes of consciousness, but since the evidence is clear that mind is correlated with cortical-synaptic activity, I shall suppose that some sort of integration and intensification is necessary to produce the unity of our psychic life. It will be noted that in this view I am not denying that secondary qualities are in the organism. I am asserting that colors (and all secondary qualities) are sometimes *both* subjective and objective. In this view an identical (or analogous) process occurs in the organism when it is conscious of the "red" of the rose as occurs out in the environment from where the spectral correlate of the sensory quality comes. Does this mean that the consciousness of color consists of frequencies (ether vibrations) in the visual cortex of the same nature as those in the external medium of light waves? I shall not attempt to answer this question until we arrive at that point in the brain. To get there it is necessary to proceed from a discussion of the physical basis of color through the physiological to the psychocerebral basis of light and color. The first step, therefore, is to review what is

[29]

known of the relation of radiant energy
to matter.

THE PHYSICAL BASIS OF COLOR

ON the physical side light has been con-
sidered as consisting of wave motions in
the medium called the ether of space.
This statement is put in the past tense
because there is now some question as to
the existence of this hypothetical medium.
The facts of the quantum theory of energy
suggest that light is corpuscular in nature,
rather than undulatory. However, if the
four-dimensional space-time manifold of
relativity theory is substituted for the
ether, we can still say that light consists
of periodicities.

For the present I see no objection to the
statement that color arises in nature only
under certain conditions of inter-relation
between radiant energy and matter. This
relation is that of the *absorption* of certain
wave-lengths and the *transmission* or *re-
flection* of others. A so-called *black-body*
is one which absorbs completely radiant
energy of all frequencies. The opposite
of a black body is one which reflects all

wave-lengths. If all the light is transmitted the substance appears transparent, and if all the light is reflected the body appears as a *white* object. *Color is the unabsorbed remainder which is reflected by objects upon which fall those waves of radiant energy lying between the specified limits to which the human retina responds.*

There are two kinds of absorption. If the absorption of light takes place equally throughout the entire range of the visible spectrum the object appears colorless. This is termed *unselective* absorption. But certain substances possess the property of absorbing certain definite portions of the spectrum and transmitting or reflecting the remainder. This is *selective* absorption. The color of a substance depends on the nature of these unabsorbed rays. *A red substance is one in which the blue-green region of the spectrum is absorbed,* and so on. The physical basis of color is the selective absorption of light.

It is universally agreed that the color of a substance depends on its structure. Since, in the atomic world, the electrons are active in the production of light they must first be considered. In the Bohr

theory the atom is pictured as a miniature solar system, with the electrons revolving about the nucleus corresponding to the planets revolving about the sun. (To explain certain phenomena the Bohr theory is being supplanted by the Schrödinger "wave mechanics," but I do not see that this bears directly on our particular problem.) The important point for us is that the absorption of light is here held to be due to the jumping of an electron from one orbit (of a "stationary state"), to another, the difference in "energy level" bearing a simple mathematical relation to the frequency of the light which produced the jump. Some substances, after being exposed to light which they absorb, can reradiate light. Here the electrons are supposed to jump from one orbit to another, and Millikan has shown that several jumps may take place *simultaneously*. *Phosphorescence* and *fluorescence* are the terms applied to this process of the radiation of light, designating, respectively, whether the period of glow is long or short. We shall have more to say about this later; in the meantime we must next take up the chemical basis of color.

THE CHEMICAL BASIS
OF COLOR

CHEMISTS have long recognized that the colors of solutions bear a definite relation to chemical constitution. (The litmus paper test for acids is a special application of this.) Without any deeper understanding than that yielded by the empirical results a fairly successful technology for the production of dyes and stains has been developed. Commercially two methods of producing color are available (*a*) By the use of inorganic chemical substances, color being due to the presence of some color producing metal. The metallic pigments (or paints) belong to this class. (*b*) By the use of substances belonging to carbon chemistry. To the latter class belong the coal-tar products. It is from the analysis of these derivatives of the hydro-carbons obtained by the distillation of coal-tar that most of our understanding of the relation between color and chemical constitution has come. It will therefore be advisable to survey this information briefly.[1]

[1] An excellent summary of this information is given by Jocelyn Thorpe in an article "Colors, Stains and Dyes," in the *Proceedings of the Royal Institute of*

We have seen that color depends on the differential absorption of light waves by matter. The majority of carbon compounds (of which hundreds of thousands are known) are colorless, in the sense that they give general absorption throughout the visible spectrum. But some of them are colored, and the staining and dyeing effects are bound up with some special condition of the element carbon. Ordinarily the greater number of known carbon compounds are "saturated," in the sense that the affinities of carbon for other chemical substances are satisfied. These saturated compounds show general absorption, and therefore no carbon compound of this type possesses color. But when carbon combines with itself by more than one valency (bond or linkage) an "unsaturated" condition may arise. This unsaturated configuration is less stable than the saturated, because there is the tendency for the carbon atoms to satisfy their bonds by acquiring the hydrogen and oxygen atoms necessary to stabilize the group. The for-

Great Britain, Vol. 24, 1925, 408-416. I am indebted to this review for some of the information herein stated.

mation of a linkage thus produced endows
the carbon compound with the property of
selective absorption in the visible region
of the spectrum.

The abstractness of this discussion may
be relieved by a concrete example. Ben-
zine shows selective absorption in the ultra-
violet region of the spectrum (and has
therefore been said to be "chemically col-
ored"), but it is visibly colorless. But the
derivatives of this substance may be made
to exhibit color by modifying the molecular
constitution leading to absorption. When
this is done the absorption then falls into
the visible range of the spectrum, thus pro-
ducing color. Kekule's conception of the
structural formula of benzine as a sym-
metrical hexagon provided a structural
basis for the conjugated system of linkages
necessary to explain the color of organic
substances. Now any desired color can be
obtained by altering the group attached to
this skeleton so as to throw the absorption
into that region of the visible spectrum de-
sired. The simplest visibly colored mem-
ber of the series thus obtained is quinone,
which is easily produced by hydroquinone
through *oxidation*, and is converted into

hydroquinone on *reduction*. (This is important. The explanation of the electrical basis of oxidation-reduction, which underlies the bioelectric production of conscious color, will be given later.)

We must now ask ourselves what the intimate nature of this remarkable alchemy may be. Since color may be said to be *filtered* light, the most general solution would seem to consist in regarding colors as being due to some sort of *resonance* effects. A red solution would seem to be one in which the spectral blue-green rays found something to throw into sympathetic vibration with themselves, and were therefore selected out, whereas the remainder passed through or were reflected. We tend to see the complementary color of the one which is absorbed. Earlier theories regarded this synchronization as consisting in an attunement between *molecular* groupings and radiant energy. More recently the tendency has been to look for this synchronization in *electronic* behavior. This is especially true of the explanations of color presented by two chemists in America. Developing the view which G. N. Lewis proposed, that the vibrating

components of a dye must be electrons, and not the atoms, and that color development occurs when we have an odd number of valence (outer) electrons in an atom or a compound, Julius Stieglitz [1] comes to the conclusion that the absorption of moving light waves and the passage of unabsorbed rays is due to intra-atomic vibration. The process is analogous to the production of tones from a stringed instrument.

Dr. Stieglitz emphasizes the point which was previously noted, that the explanation of the fundamental relation holding between electron vibrations and the structure of the dye molecules is to be found in the fact of *reduction* (by which every dye becomes colorless) and oxidation, whereby the color is restored. Both oxidation and reduction have in common their dependence on the freeing of the valence electrons from the ordinary intra-atomic restraints.

We now face the problem of establishing the biochemical basis of color. To this task we turn, but it must be kept in mind that I am distinguishing between the bio-

[1] "A Theory of Color Production," *Journal of the Franklin Institute*, Vol. 200, 1925, 85-51.

chemical and the neural, and that we must examine the neural conditions later on.

THE BIOCHEMICAL BASIS OF COLOR

WE are told in Genesis that God put into man the breath of life. Since times immemorial men have been accustomed to thinking of *life* as a supernatural entity. But iconoclastic scientists are now rapidly breaking down this distinction between the chemistry of the inorganic (mineral) world and the chemistry of the organic or vital world. Organic chemistry, as every school boy now knows, is carbon chemistry. This, presumably, is what led Bertrand Russell to declare that men are merely lumps of impure carbons. At the same time, we must not forget the equally important fact that man, the lord of creation, consists of about four buckets of water. Living matter probably took its origin in the sea. The blood stream still resembles the salt water of the ocean.

The preponderance of water in organisms is especially important because water has the property of accelerating all kinds

of chemical reactions. This is true of the inorganic world (e.g. the rusting of iron, etc.) as well as the organic. As Professor A. P. Mathews tells us in his *Physiological Chemistry*, living matter is peculiar in the *speed* with which hydrolytic, oxidative and reductive reactions occur in it. In organisms, in addition to water, various other agents, called *enzymes*, promote *catalysis*. These enzymes will act only on substances having particular *molecular forms*.

One reason why carbon compounds form the building stones of living matter lies in the fact that carbon has four chemical valences, and therefore possesses the power of combining with other elements to form the complex substances like the proteins and carbohydrates. Another reason lies in the fact that the majority of substances elaborated by the animal organism are *optically active*, and carbon is the optically active element *par excellence*. Now what does "optically active" mean?

Substances and liquids are said to be optically active when they rotate the plane of polarization of a beam of light passing through them. When light is given a right-handed twist the liquid is called

"dextro-rotary," and when in the opposite direction, it is designated as "laevo-rotary." It is interesting to note that organisms can discriminate between dextro and laevo-rotary compounds. It was claimed by Pasteur that the power of building up optically active compounds is a unique prerogative of life. How and why carbon rotates the plane of polarization of light is a mystery. The only speculation at hand to explain it involves a discussion of the arrangement of atoms and molecules in organic compounds. I shall not attempt to explain this in detail, but merely point out that life may be only a matter of stereo-chemistry, the study of tetrahedral carbon arrangements. The only reason I mention this matter at all is because it seems to me that there *must* be some intimate relation between color production and optically active carbon compounds.

Let us now turn to a brief statement of some of the important more complex carbon compounds. Living matter contains many substances insoluble in water, though they are soluble in ether, chloroform, alcohol, etc. (The effects of anaesthetics

and drugs in producing unconsciousness, and the narcosis of intoxicating drinks, are probably to be explained by this fact.) These substances, of which there are many, are given the name of lipins (Greek, *lipos*, fat). Among them are the phospholipins (or phosphatides) containing large amounts of phosphoric acid. Cholesterol and the phospholipins make up the essential substratum of living matter. Phosphorus is present in relatively large quantities in the brain, and it is this fact which led a German investigator to say, "ohne Phosphor keine Gedanke," (without phosphorus no thought). Cholesterol, an important lipin in the brain, though it contains no phosphorus, consists of five benzine rings linked together. It is remarkable for its power of forming pigments, and for its color effects.

Thus far we have been discussing some of the *substances* in living matter. Let us now turn to an examination of the ways in which these substances *behave*. These fats undergo certain chemical reactions, such as oxidations and reductions. Their behavior can be duplicated by linseed oil, which is one kind of unstable fatty acid.

[41]

T. Brailsford Robertson, A. P. Mathews, and G. W. Crile have noted the curious resemblances between linseed oil and protoplasmic respiration, memory, and growth. Linseed oil takes in oxygen and gives off carbon dioxide, like a nerve. Ultra-violet light accelerates this respiration, just as it does in protoplasm. The curve of absorption in oxygen is an S-curve; the reaction begins slowly and then speeds up. Such a curve represents an autocatalytic process. Robertson, who has shown that the curve of growth is such an S-curve, also points out that the Weber-Fechner law is in accord with his autocatalytic view. Oil can also be shown to "remember" the lessons it learned on exposure to light, and to "forget" if left too long in the dark. One difference between linseed oil and the oxidizing behavior of the fatty acids in organisms is that in living matter oxidative accelerators, called oxidases (such as the *quinones*) increase the speed of organic oxidation.

The fact that the brain is abundantly supplied with optically active, long chain, unstable carbon compounds, the phos-

pholipins including cephalin and choles-
terol, supplying reservoirs of potential
energy, probably throws light upon the
problem of the relation of consciousness
to the body. The fact that the fatty acids
are rendered unstable by partial oxidation,
and that in this condition they have an
almost explosive action, may explain why
it is that the intensity of a response is
sometimes totally out of proportion to the
intensity of the external stimulus. In this
connection it is worth referring to the
interesting suggestions which Dr. A. J.
Lotka presents in his masterly book,
Elements of Physical Biology, namely,
that the conscious state may be in some
way correlated to that transitional state
through which matter must pass on its way
from one stable molecular configuration to
another (p. 391).

Phosphorus is one of the main con-
stituents of the nucleus of the cell, and
this, coupled with the possible truth of the
idea which Dr. Crile presents in his
Bipolar Theory of Living Processes, that
the central nervous system is the descend-
ant of the nucleus of the cell (and the
nucleoproteids are rich in phosphorus),

lends weight to the suggestion that consciousness is a kind of phosphorescence in the brain. This view is in harmony with the fact established by Nodon that organic substances of high vitality can take their own photographs. It is also consonant with Dr. Ladd-Franklin's deductions concerning nerve radiation, about which we shall have more to say later.

May I remind the reader that in an earlier section we lead up to the idea that the photo-chemical (or perhaps photo-electrical) processes in the retina were correlated with oxidations and reductions which provide the chemical basis of color in nature? Now if we can show that oxidative-reductive processes provide the physiological conditions of consciousness, we will have achieved a synthesis highly satisfying in its æsthetic unity. To accomplish this we must show that the oxidation-reduction processes in the organism are electrochemical processes. To this we now turn.

Every activity of protoplasm is accompanied by an electric current, the "blaze" current or current of action. This electrical disturbance, as Mathews suggests

(*ibid*, p. 261) may be "the direct result of oxidation, every oxidation involving a minute current when the positive charge is passed from the oxidizing to the oxidized body." This leads him to the idea (p. 595) that when the nerve impulses play back and forth over the brain they are accompanied by the pale lightening of the negative variation, and it is this "pale lightening" which we recognize in ourselves as consciousness. This is consistent with the fact that consciousness can exist only for a few moments without oxygen. Truly, the soul is breath or *pneuma*.

The view that oxidation in protoplasm is at bottom an electrical process receives support from investigations which were summarized in a recent article on the "mechanism of oxidation in living tissue."[1] One paragraph may be quoted to illustrate and confirm this idea:

"Recent work has shown that molecules are oriented in a surface, so that it may be considered as a mosaic composed of different molecules arranged simply or in groups in a definite pattern, which is characteristic for each cell, but varies with

[1] *Nature*, June, 1926, p. 910.

growth and activity. This molecular arrangement will lead to the existence of varying electric fields scattered over the surface of the cell, and the author considers that a molecule is 'activated' and so becomes susceptible of oxidation (or reduction), when it comes under the influence of one of these fields, which causes a shift of electrons from one atom to another of the molecule."

Before the physiologist can claim to have a really adequate picture of biochemical processes one of the problems which must be solved is that of the nature of chemical activation. At the present time the mechanism of even the simplest chemical reaction is not understood. But one of the most plausible of the suggested explanations of chemical activation is the radiation theory—that light quanta interchanges are necessary to activate chemical processes. At the risk of digressing I would like to quote the following daring hypothesis put forth by Professor Mathews in his essay in the co-operative volume, *General Cytology*:

"It is perfectly correct . . . to speak of living and dead hydrogen atoms. We

can even go farther with the simile, if we wish, and say that when the living highly reactive form of the atom passes from the dead, unreactive form, the soul of the atom escapes at the moment of its death, for the ray of light leaves the dying atom and travels onward in space, until perhaps it encounters and is absorbed by some other dead hydrogen atom, which it again raises to life by thus giving it a soul."

This view, in addition to refuting the widespread notion that there is no romance or poetry in science, makes the doctrine of the present writer, that the relation of consciousness to the nervous system is simply the relation of fields of energy to matter, less ridiculous than it has appeared to some.

NERVE CONDUCTION AND QUALITIES

In the foregoing pages we have seen that the chemistry of life is the chemistry of carbon, and that the oxidations and reductions of carbon compounds, certainly objectively and perhaps subjectively in the organism, are the chemical conditions of

color. However, nerves made of apparently the same sort of stuff as the optic nerve (such as the auditory nerve) also transmit sensations, and these sensations are qualitatively different. That fact introduces the following problem: To what extent is the process of conduction the same in all the nerves? Is nerve transmission the same in vision as in audition? If so, how are the qualitative differences arising in the different receptors transmitted? If not, how must the Nernst-Lillie picture of nerve conduction be modified to take care of the qualitative variables? Before trying to answer these questions let us get the main facts of visual experience before us.

THE FACTS OF VISUAL EXPERIENCE

VISUAL experience, like auditory, has three aspects. These basic functions are sometimes designated by different terms, and the absence of uniformity of terminology has caused much confusion. I shall designate these aspects by the following terms:

(*a*) Color-tone or hue

(*b*) Light-tone, tint, brightness, or luminosity

(*c*) Saturation or chroma

It is generally agreed that the *color-tone* series depends on *wave-length,* and that the eye is sensitive to light waves lying between 760 millionths of a millimeter, giving sensations lying in the red end of the visible spectrum, and 390 millionths of a millimeter, constituting the short wave-lengths lying in the violet end. The *brightness* or *luminosity* of light is correlated with the energy of the stimulus, i.e., the *amplitude* of the wave. The *saturation* series depends on the *simplicity* or *complexity* of the wave, i.e., on the mixture of the short and long wave lengths. Monochromatic wave-lengths give the purest saturation. All visible objects also have *shape* or *form,* and this is grasped not only through the retinal pattern, but also through the eye movements by means of which the shape is apprehended in its entirety.

Even though one hold that color is a reality which arises only in the visual cortex (or the mind regarded as the psychical series correlated with cerebral states),

some sort of basis must be assigned to the processes preceding the entry of the physiological excitation into the cortical center (occipital lobe) in the brain. In other words, *every theory of vision involves a theory of the chemical process in the retina, and eventually implies a theory of nerve conduction.* The way in which the doctrine of the conscious apprehension of color qualities in the brain determines one's theory of what happens in the optic tracts is illustrated by Helmholtz's trichromatic theory of vision. According to Helmholtz the resultant of all the various light stimuli can be completely represented as a function of three variables. The equation

$$C = xR + yG + zB$$

states that any general sensation of the type C can be produced by combining the fractional parts (x, y, z) of the three sensations of independent fixed types R (red), G (green), and B (blue). In accordance with this trichromatic theory Helmholtz assumed three different types of nerve fiber each carrying its own impulse.

But it is also possible to assume that the

same nerve fiber can carry several types of nervous impulse. This is the view which is adopted in the Hering and Ladd-Franklin theories. Thus we see that to explain the various aspects of color vision one may assume (*a*) different kinds of receptors and nerve fibers in the visual mechanism; or (*b*) one single nerve fiber capable of transmitting manifold qualitative differentiations. Compromises between these views are also possible.

The problem on the physical and chemical sides is by no means simple; but when we raise the additional problems of the physiological basis of color the complexity seems to be immeasurably increased. The problem of the visual expert is to reveal the physiological conditions corresponding to the above three main aspects of color vision, at the same time explaining the supplementary phenomena of color mixture, retinal rivalry, fatigue, adaptation, after-images, etc. Keeping these facts and possibilities before us, let us return to the questions raised a moment ago. In trying to answer them it will be convenient to contrast more

recent views with the older doctrine of the
specific energies of the nervous system.

SPECIFIC ENERGIES AND THE
"ALL OR NONE" LAW

THE specific energies theory does not
occupy the important position in contem-
porary psycho-biology which it formerly
held. The reasons for this are several,
but *the single fact that the same nerve
fiber may transmit several different sensa-
tions* (acid and alkaloid, in the case of the
taste-bud receptors in the tongue, and a
parallel case can be found in vision) *puts
an end to the specific energies theory.*
However, some of the facts which orig-
inally called forth this theory still remain,
and if we reject Müller's doctrine we must
find a substitute for it. What is the hy-
pothesis which is the most likely substi-
tute for it?

In his article in *The New Realism*, Pro-
fessor E. B. Holt has suggested a *neural
periodicities* theory, which he thinks will
serve as a substitute. A somewhat simi-
lar view has also been proposed by L. T.
Troland, and I turn to this view because

it serves as an introduction to the important doctrine of chronaxy developed by Lapicque.

The research of Adrian, Lucas, Forbes, and others has proved that the "all or none" law, stating that if a cell responds at all it will react to its maximum capacity, holds for nerve cells as well as for muscle cells. Add to this fact the derivative fact of the refractory period (about .002 of a second), and it is obvious that the number of impulses which can traverse a single fiber is limited. This seems at first to make our second hypothesis—that of a nerve fiber transmitting manifold qualitative variations—difficult to conceive. In the case of vision the problem is to show how gradations of quality (red, green, etc.) as well as of quantity (or intensity) can be transmitted by the same nerve fiber.

As Professor Troland has pointed out, some experiments seem to show that we must reject the notion that the *intensity* of visual sensations depends upon the number of fibers excited. Now if we correlate the intensity of visual sensation with the frequency of the quantal or all or none pulses, then the qualitative aspect must de-

pend on something else. Troland's suggestion is that the qualitative aspects (*hue* and *saturation*) may be represented by some sort of "group frequency" of the pulses.

This suggestion is expanded by Troland in his excellent book *The Mystery of Mind* (Ch. 13). Troland there ventures the suggestion that the pulse frequency is responsible for the cortical process underlying *brilliance* of color. The particular *hue* which is exhibited may depend upon the exact *form of modulation* (employing an analogy from radio-telephony) which is impressed upon the nerve currents. Troland supposes that the cortical neurones are able to differentiate the various aspects of visual experience because this set of elements is somewhat like a radio receiver "tuned" to particular wave lengths. There are nerve arrangements tuned to "red," and the "red receiver" will pick out that special rhythm which represents red in the nerve currents. The conscious factors, such as red, are apparently simple, while the corresponding physical factors are quite complex. As an explanation of this Troland suggests

that the physicist probably overemphasizes the structural aspects of the things he studies. Troland believes that there are special electrical field structures underlying conscious qualities. The electrical fields of force may be regarded as unitary things (responsible even for the *form-quality* in the theory of *gestaltsqualitäten*) which the physicist tends to ignore.

The only criticism the writer has to offer of Troland's view is that the hypothesis of specific receivers seems to assume the doctrine of stabilized localization of function, which Sir Henry Head has shown to be false in general, while K. S. Lashley has shown that the center of vision may shift around in the cortex. The writer will suggest his hypothesis to account for this fact of the transfer of function later.

THE DOCTRINE OF CHRONAXY

THE foregoing discussion leads us to the conclusion that *the notion of rhythms or frequencies of neuronic discharge* (i.e. *spatio-temporal periodicities*) *is the only adequate substitute for the doctrine of specific energies.* The conjecture that

[55]

each nerve impulse is the expression of a characteristic discharge frequency is receiving some experimental support. In his book *Protoplasmic Action and Nervous Action*, R. S. Lillie tells us that presumably the electromotor rhythm of nerve and muscle cells is determined by the rhythmic discharge of cerebral nerve cells. So far as the present writer is informed, the first suggestions of this doctrine came from L. Lapicque.[1] In his view nerve impulses pass from one neurone to another over the synaptic junctions when the two are in attunement (or isochronous), and do not pass other junctions where the time interval is not in accord (heterochronous).

It is generally agreed that the physiological factors which determine the direction of a nerve impulse are *heredity, habit* and *fatigue*. But habit itself is controlled by several factors. It is recognized that in *learning* new responses the factors which operate are the *recency, frequency,* and *intensity* of the stimulation. In Lapicque's view stronger excitations (of an

[1] Brief expositions of Lapicque's doctrine of Chronaxy are given in C. K. Ogden's *Meaning of Psychology,* C. J. Herrick's *Neurological Foundations of Behavior,* and H. Piéron's *Thought and the Brain.*

increased intensity) may alter the chronaxy of a neurone, resulting in irradiation of a nervous current, thus producing a more intense or a different reaction. The way in which the establishing of a synchronism between neurone frequencies may underlie learning is seen in Pavlov's famous experiment on the "conditioned reflex," where sounding a tuning fork becomes the substitute stimulus for the salivary secretion in the dog. (For a more detailed account of this, see Ogden *op. cit.*). This doctrine may also be extended to explain some of the facts of musical æsthetics. Dr. P. R. Farnsworth has suggested to the writer that the fact that musical preferences (for tone combinations) are largely a matter of habit (repetition), and that these preferences can be changed by "education," may be explained by this doctrine. He makes the further assumption: where two neurones are excited at different frequencies, the common neurone into which they enter (where there is one) takes on first the frequency of the lower tone, then that of the upper, and then a multiple of them. This would

seem to work in with the low primary fusion and the later increase of fusion.

How these rhythms and attunements are to be understood in detail is not so clear. The most satisfactory picture of the intimate mechanisms underlying neuronic tuning with which the present writer is familiar is presented by Dr. H. M. Johnson, whose work on "Sleep" has received much publicity lately. In Dr. Johnson's view the explanation of chronism (as he calls it) lies in the relation between the discharging frequency of the afferent cell and the charging frequency of the efferent one (if the reader is not interested in this the following two paragraphs can be skipped).

The mechanism which is suggested consists in visualizing the neurone as a conductor with a permanent membrane acting as a sieve, permitting the transfer of the charged particles. Bayliss' notion of a limiting membrane is rejected, because the Langmuir layer, assumed by Bayliss, will not perform the function which chronism requires. The *surface-membrane* has a *surface-film*, which is simply a Helmholtz double-electric layer of ionized molecules

adsorbed to the surface membrane. When the field of force is constant the elements of the membrane assume a definite orientation, and a reversal of orientation, produced by an alteration of the electro-motive force, is necessary to render the film permeable to an ion to which it was previously impermeable. Doctor Johnson assumes that the time required for orientation of the molecules of the surface film is specific for a given cell, and that the reciprocal of the orientation-time represents the number of oscillations of the surface charge. This film frequency, F, bears a mathematical relation to the discharge frequency, *f*, of the cell.

The all or none law, in this view, takes its origin (in part) in the fact that a second process of "irritation" must await the preparation of a fresh supply of material, including the proper orientation of the molecules. Whether conduction will occur from one cell to another depends on whether the two cells are "tuned." The film of the cell is conceived to possess a mechanism analogous to the grid of a thermionic tube, acting as a tuner. Learning is thus the forcing of oscillation-periods of

neurones into efficient relation with each other. The reader must go to the original paper [1] for a fuller exposition of the ideas.

So far as I can see this view explains satisfactorily all the phenomena which the behaviorist conceives it his problem to deal with. However, in spite of the fact that Johnson's doctrine of chronism provides a substitute for the specific energies theory, I doubt whether sufficient provision is made for the qualitative elements of consciousness. Dr. Johnson's view of this (expressed in a personal communication with the writer) is this: "A 'quality' may perhaps be explained when the physical conditions under which it appears, or under which it is reported to appear, are adequately described. By definition the quality is not the physical conditions—e.g., a certain yellow is not a certain vibration frequency or a superposition of a number of vibration frequencies. To identify the quality with the latter, one simply substitutes definitions. What is the use?" In this view quibbles about the "riddle" of

[1] "A Simpler Principle of Explanation of Imaginative and Ideational Behavior and of Learning," *Journal of Comparative Psychology*, Vol. VII, 1927, 187-234.

qualities seem to be nothing but disputes concerning definitions.

I am not at all sure but what I can agree to this—provided we insist that the quality is identical with *all* its physical conditions. Now part of the physical conditions of external light are wave motions. If *all* the physical conditions are present in *perceived* light, wave motions must also somehow be present in the corresponding brain functions. Professor Troland, as we have seen, admits this in his views concerning the importance of fields of force in cortical processes. Several years ago I also proposed a similar view. I return to this idea in the present essay. In addition to the assumption that *the nerve process preserves something corresponding to all the properties of the external wave frequencies and foreshadows all the characteristics of the cortical processes, the additional assumption is made that in the brain there is reinstated a typical form of vibratory phenomenon somehow corresponding to the original wave frequency which acted as the stimulus.* Now we might argue until doomsday about such matters, but fortunately evidence is forthcoming that

some sort of light is present in nerve conduction (at least in visual experience) and this experimental evidence takes precedence over all theoretical considerations.

CONSCIOUSNESS AND NERVE FIBER RADIATION

ONE of the interesting phenomena discovered by Purkinje consisted in calling attention to the fact that in a perfectly dark room a band of red light will be seen to have projecting from its sides reddish blue arcs. The explanation hitherto given of this is that the action current of the optic nerve fibers which carry the red light excitations causes a secondary induced excitation in the adjoining nerve fibers. But as Dr. Ladd-Franklin [1] points out, when the eyes are closed a true after-image of this phenomenon can be obtained. Since, as Lazareff has demonstrated, an after-image can be produced only in the rods and cones of the retina, and these can be

[1] I am indebted to Dr. Ladd-Franklin for a copy of the paper, "Proof that Nerve When Excited, and Perhaps Also When Not Excited, Emits Physical Light," read before the Harvard Medical School (to appear in her forthcoming *Color and Color Theories*).

stimulated only by physical light, secondary induced currents cannot produce the effect. This explanation will not hold. The true explanation is that nerve fibers, when stimulated, give off radiation. What one is really seeing is his own nerve currents—in this case the bipolar cells which surround the image of the red band. Nerves may shine by their own light, and it is really correct to say that one can see his own nerve currents. This light will be visible when the nerve is not myelinated (or covered by the medullary sheath).

But if all nerve fiber in a state of activity emits physical light (or some radiation of a higher frequency which becomes light through fluorescence) why has this fact not been discovered long ago? There are two reasons: (*a*) most work done on nerves is done on myelinated nerves, and (*b*) one does not usually study nerves in a dark room. Moreover as Dr. Ladd-Franklin points out, since it has been shown that carbon dioxide is given off by the unexcited nerve, it is possible that light may also be given off by unexcited nerve.

While Dr. Ladd-Franklin has not added

any theoretical speculations to the statement of the facts, it seems to the writer that they may help to solve the problem of the relation of consciousness to the nervous system. If it is true that secondary qualities are in physical reality, and that they are therefore *in* the nerve currents, it follows that when light is emitted by the excited nerve this light *is* consciousness. If we imagine ourselves to be *inside* the molecules or atoms which are absorbing light the color we would see would be the complementary of the color which some one *outside* the molecules would see as reflected light. In this sense the internal universe of consciousness is the external universe turned outside-in, and the objective universe is the internal world turned inside-out. Such a twist of the surface of reality can always be made by going into a higher dimension, and I suppose that for beings living in the fifth dimension (i.e. a dimension at right angles to our four-dimensional space-time universe) our material world would be invisible because it would possess no color. Lest these speculations should seem like vagaries of a disordered mind, may I suggest that the

[64]

present age is one in which insane ideas flourish. No less an authority than A. S. Eddington assures us that some of the spiral nebulae may be phantoms, and that some stars are optical ghosts revisiting their old haunts! Who is crazy now?

With a certain amount of poetic license life has been compared to a candle, with death as the snuffing of the flame. The relation is much deeper than that suggested by a figure of speech. Life *is* literally a process of combustion. Each nerve cell is a little wick, with its own lamp of oil. Consciousness depends on cerebral oxidation because it is a synthesis of many little glowings. The writer was originally much taken with the idea that consciousness might be a phosphorescence (or oxidation) of the phospholipins, but the fact that the cholesterol and phosphorus in the brain are contained mostly in the medullary sheath, while nerve fiber radiation is visible only in non-myelinated nerves, has led him to abandon this view. But I see no objection to the analogy that conscious perception resembles neural photography—the cinematographic viewing of the "latent

[65]

images" as they are "developed" by the electrochemical reactions in the brain. Introspection on remembered experiences, and dreaming, would lack the vividness of true perceptions because they lack the intensity of stimulation (frequency of nerve discharge) which goes with the excitation of a receptor. If such speculations come anywhere near the truth we are then close to the solution of a problem which has baffled the ingenuity of philosophers for several thousand years.

SOUL AS HARMONY OF THE BODY

IT is now time to gather together the various tangled threads of our argument and, if possible, knit them together into a seamless whole. In the foregoing pages I have tried to make the following points: (1) The oxidation and reduction of carbon compounds underlie the production of color in chemical substances; (2) the chemistry of life is the chemistry of carbon compounds; (3) the doctrine of chronaxy supplies a suitable substitute for the specific energies theory; (4) that by associating the frequency of neurone discharge

with the attendant electro-magnetic fields of force (of which "bioluminescence" in vision is but a special case) we have provided a basis for the qualities of conscious experience the presence of which the behaviorist cannot explain by his system; (5) that consciousness of color therefore somehow reduplicates the physical conditions of color; (6) because secondary qualities inhere in physical reality.

Is there any relation between these several ideas? Are they mutually implicative? This I have tried to show, but to bring out more clearly the nature of this interdependence of chemistry and consciousness an apparent inconsistency must be removed. To do this it is necessary to state the two alternatives which seem to face us: Is conscious color produced by (a) the assimilation and dissimilation of carbon compounds, specifically correlated with the photo-chemical reactions in the retina, or (b) is the discharge frequency of the cortical receiver independent of its chemical structure, so that the "same" neurone can have its chronaxy altered without altering its chemical composition?

For the following reasons it seems to

me that the second alternative must be rejected. The nerve cell is a *generator* as well as a *transmitter*, and both these processes involve the breaking down and resynthesis of long chain carbon compounds. (For our purposes it is not necessary to state where the potential energy of the nerve cell is stored.) This means that while at any given moment structure determines function (chronaxy), over a longer period of time function will slowly alter structure through use and disuse. This means that the kind of quality associated with the chronaxy of a cell (or set of cells) is determined in part by the chemical constitution. Now the kind of carbon compounds of which a cell is made is an expression of the way in which it has functioned in the past. Specifically, this suggests that there may be some relation between color and the probable benzine ring structure (of the cholesterol, perhaps) in the brain. At present I am unable to carry this line of thought further.

Does this view that structure and function are mutually interacting factors throw any light upon the mooted problem of the inheritance of acquired characteritics?

Does it tell us anything about the origin of instincts? Let us take the second question first. Hereditary modes of response are usually explained as being the expression of "innate pathways of low resistance." This, in a theory of chronism, means an inherited synchronism between nerve and muscle cells. But how can habits and conditioned reflexes be superimposed upon preëstablished chronaxies? To understand this we must note that the inherited modes of response are probably due to something permanent about the cell —perhaps the molecular carbon structure of the cell and the orientation of the molecules in the cell membrane. Now if the repetition of a stimulus can alter these, then even the so-called "innate tendencies" can be modified. In any event there is no difficulty in supposing that the newly acquired responses can be integrated into or superimposed upon the inherited chronaxies. The alteration of chemical structure which constant functioning (due to repeated stimulation) compels may also explain the "re-education" and transfer of function previously noted.

It is also within the range of possibility

that acquired structural-functional modifications may be hereditarily transmitted under certain conditions. (Professor Wm. McDougall, along with several others, claims to have experimental evidence of this.) Probably one of the conditions is that the animal must "desire" the modification. (This is sometimes overlooked in experiments on cutting off the tails of animals through successive generations.) The view that in ontogenetic development functional stimuli can determine the growth of embryonic nerve cells is argued for by Kappers in his doctrine of "neurobiotaxis." He also calls attention to the fact that his doctrine is consistent with Lillie's work on the rôle of oxidative processes in growth, and that Professor Child has called attention to the probability that during the evolution of tissues electric conditions occur similar to those in stimulation. But the exact process by means of which this embryonic polarization (of bioelectric currents) might acquire phylogenetic engrammatic character is not explained. The only scheme thus far developed to explain this is that pre-

sented by Eugenio Rignano in his *Biological Memory*, and other works.

If it is true that function builds up structure then it follows that matter is mind hidebound with habit, as one philosopher puts it. If the recurring types of stimuli in time build up permanent substrata of response, it is correct to say that an organism is simply "bound" energy. This is in harmony with the view of theoretical physics concerning the reciprocal convertibility of matter and energy. The writer hopes some day to present a scheme which may explain the appearance of an organ as the eye (which Bergson states was produced because the organism has a *desire to see*) in terms of the present doctrine.

The existence of a cerebral mass, hereditarily given, enables us to understand why human beings are conscious in a different way from that in which an excited iron wire is conscious. The iron nerve will not see the red of the rose because the physical conditions of color cannot be reconstituted. To do this we must have a mechanism to act as a step-up transformer. This can be accomplished by the

resistances offered at the synapses. (This mechanism, which also acts as a "tuner," is compared to the "grid" of a thermionic tube by Dr. Johnson, and others.) The failure, as in the case of color blindness, of an organism to respond to an external quality is due to the hereditary deficiency of the appropriate apparatus necessary to reconstitute the physical conditions.

On the other hand, it is also possible that the brain over-interprets the perceptions coming through the senses. After having disposed of as many phenomena of visual science (such as fatigue, adaptation, after-images, etc.), as might be referred to purely retinal processes, there still remain many facts which cannot be interpreted by supposing them to take their origin in a peripheral process. All such apparently internal phenomena as *subjective colors,* visual illusions, "beats," "summation tones," "subjective rhythm," etc., seem to be explicable only on the assumption that something is added to the perception, in the form of judgment, inference, meaning, etc., which supplements the bare "sensation." There is still some question as to whether color fusion takes

place in the retina or whether it occurs in the brain and the mind. But there is sufficient evidence from other sources showing that something is added in the sensory and motor cortex, where the appropriate movement to the stimulus is elaborated. However, the added contributions in the cortex seem to consist mainly in incorporating the contributions from the special senses into some higher unit or synthesis. This is nothing more than the tendency of individual elements to be assimilated into larger wholes of which they then become a part. It is like the absorption of separate musical notes into larger melodies and harmonies. In the field of vision this is illustrated in the fact that many objects (dots, for instance) can be grasped simultaneously in an act of attention. The difference between these two examples taken from vision and audition lies in the fact that sound sequences are temporal *sequences*, while space configurations are *simultaneous* arrangements. Now the only thing which the sense deliverances have in common is that they are vibratory phenomena of nervous currents (i.e., periodic disturbances traveling through

space and time). This seems to suggest that the visual, auditory, and other nerve impulses are integrated into the unity of consciousness through some sort of harmonic synthesizer. In such a view the physiological aspect would be represented by the basic fundamentals (of the corresponding Fourier's series) and the progressing music of consciousness would correspond to the overtones or harmonics. The mind would be the expression of the dynamic equilibrium of labile tensions in the energy-fields. Here we are embracing the view which Socrates (or Plato) rejected several thousand years ago—the view that soul is the harmony of the body!

The writer is keenly conscious of the tentative and cryptic character of these suggestions. The more we study the baffling mystery of the relation of mind and body the more difficult the problems seem to become. It seems to me that the unity of consciousness, in which temporal sequences and spacial configurations are fused, can only be understood by attempting something analogous to what physics has accomplished in fusing space and time into a single, indissoluble unity, space-

time. (Perhaps this is what Dr. Alexander intends to imply when he declares that *time is the mind of space.*) Indeed, in the present view this fusion follows necessarily from the physical fusion of space and time, for conscious qualities are *in* physical reality. This is in harmony with Eddington's statement that "all through the physical world runs that unknown content, which must surely be the stuff of our consciousness." This, of course, complicates physical reality, which becomes much richer, and almost indefinitely complex.

NEURAL FREQUENCIES AND ETHER WAVES

THE writer wishes to assure the reader that he has no desire to accelerate that already rapidly multiplying brood of "wave" theories which, starting with the now exploded "N-rays," has secured a new lease on life in the various "brain wave" theories now in vogue. Nevertheless, if consciousness of content consists of the occurrence in the cerebrum of a condition similar to that which is externally

existent in, the physical frequencies, we cannot escape the question of why it is that the presence of such waves cannot be detected by appropriate physical instruments. If we overlook experiments where the claim is made that fields of force have been detected by experiment we might explain · the absence of positive results by supposing that in the brain the frequency may be stepped-up to a point beyond which any present instruments respond. This would be consistent with Dr. Ladd-Franklin's supposition that nerve fiber in a state of activity may emit some radiation of a higher frequency than visible light, which becomes light through fluorescence. Nodon's experiments, where, if his conclusions are correct, organic substances take their own photographs, prove the presence of electromagnetic waves around these substances, for light is an electromagnetic disturbance.[1] However this may be,

[1] Experiments are now being carried on in Pittsburgh which are somewhat similar to those of Nodon. In discussing these matters with Dr. N. V. Rashevsky (of the Westinghouse Co.) and his wife I have learned that a number of papers have appeared in Russia on the ultra-violet emanations given off by plants. Mrs. Rashevsky is conducting experiments in a local hospital on radiations from onions. She exposes the plant to a photographic plate covered by a quartz plate which

another explanation of the absence of positive results might be given by supposing that the bony skull acts as an insulator. We are told by the experts that the bones consist mainly of calcium. We are also told by Bertrand Russell that the ability of a substance to stop X-rays varies approximately as the fourth power of the atomic number. The rays will therefore pass through the muscle tissues, etc., and be stopped by the bones because of the higher atomic weight of calcium. Thus an X-ray photograph of the skeleton is produced. If the same general principle holds for the frequencies in the cranium, one would not expect these frequencies to penetrate the skull—at least so long as we remain as thick-headed as we are at present!

transmits the ultra-violet, but which excludes the fumes which, according to some critics of Nodon's experiments, produced the results which the Frenchman secured. While the radiations which Mrs. Ladd-Franklin asserts are emitted by nerve fiber are not ultra-violet, but visible light, her conclusions might be harmonized with the foregoing results by way of the idea that the ultra-violet radiations become visible light through fluorescence. It is a curious fact that the ultra-violet rays, which are physiologically the most potent rays, should be invisible to the eye. One possible explanation for this I have suggested in a Letter to *Nature* for April 14th, 1928.

It occurs to me that this theory might be tested by applying a delicate electroscope to the region around the brain when part of the skull has been removed (i.e., in trepanning)—the only trouble is that under such conditions the patient is usually unconscious from the effects of an anæsthetic: that phosphorescence of the brain which we call consciousness is therefore absent, so that the emanations would also be absent. However, the ingenuity of the scientist in overcoming limitations is marvelous, and no one can predict what the future holds in store. Thus the reality of vision leads us on to visions of reality! And so nature, through the alchemy of light and color, interprets itself to itself.

THE END

CPSIA information can be obtained
at www.ICGtesting.com
Printed in the USA
BVHW051940061021
618309BV00004B/192